learn to draw

Horses & Ponies

Learn to draw and color 25 favorite
horse and pony breeds, step by easy step,
shape by simple shape!

Illustrated by Russell Farrell

Getting Started

When you look closely at the drawings in this book, you'll notice that they're made up of basic shapes, such as circles, ovals and triangles. To draw all your favorite horses and ponies, just start with simple shapes as you see here. It's easy and fun!

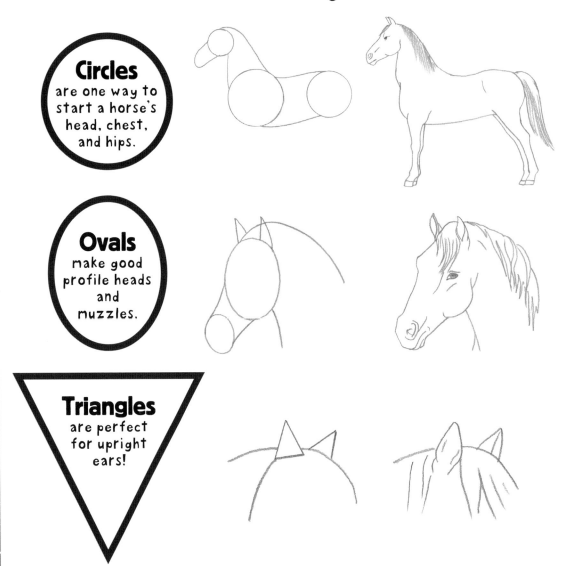

Circles are one way to start a horse's head, chest, and hips.

Ovals make good profile heads and muzzles.

Triangles are perfect for upright ears!

Coloring Tips

There's more than one way to bring your four-legged friends to life on paper—you can use crayons, markers, or colored pencils. Just be sure you have plenty of good "horse colors"—black, brown, and white, plus yellow, orange, red, and blue.

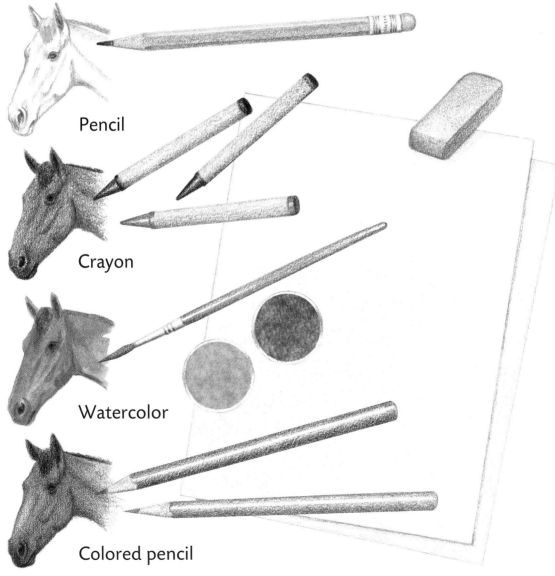

Pencil

Crayon

Watercolor

Colored pencil

Australian Pony

This sweet little pony from "down under" has a fine, delicate face and large, dark eyes. Say, "G'day, mate!"

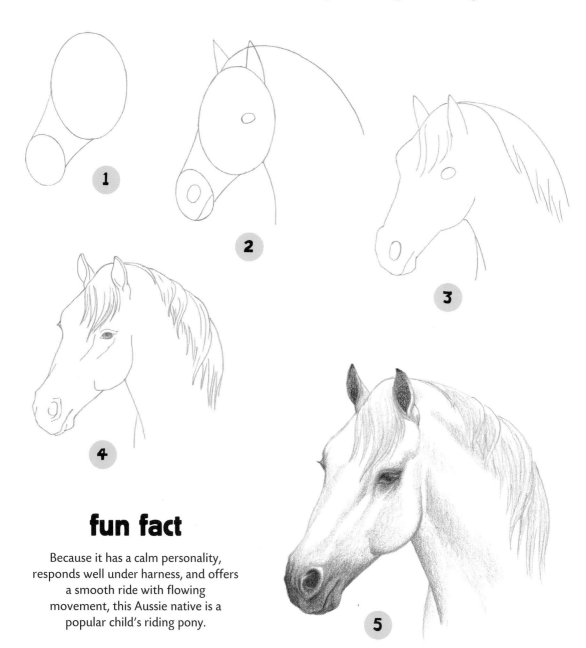

fun fact

Because it has a calm personality, responds well under harness, and offers a smooth ride with flowing movement, this Aussie native is a popular child's riding pony.

Hackney Horse

This handsome show horse is strutting its stuff—
stretch out those legs and arch that tail high!

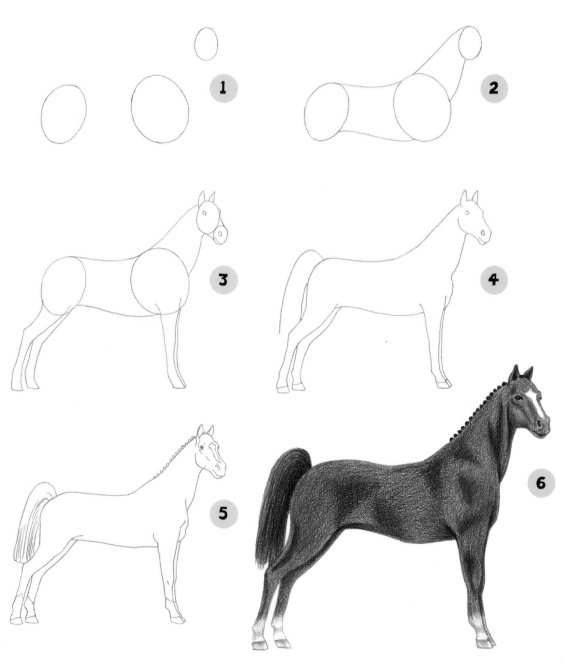

Hanoverian Foal

Start this long-legged baby with two circles for the body. Then finish with a short, brushlike tail and a stiff, upright mane.

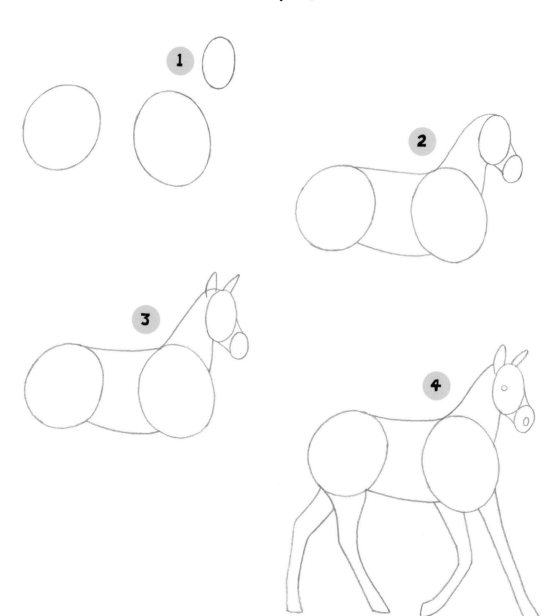

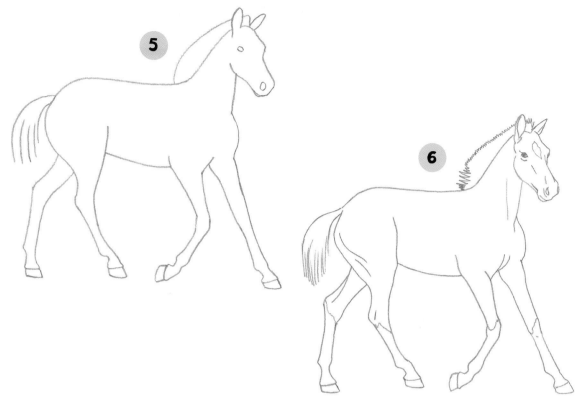

5

6

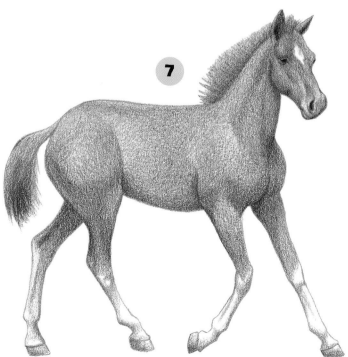

7

fun fact

The first Hanoverians worked as carriage and military horses. But the Hanoverian is now one of the most important sport horse breeds. With their long stride, powerful action, and excellent jumping skills, they have won many world championships, including a number of Olympic medals and more World Cups than any other breed!

Pinto

This color breed has a cool patterned coat that sets it apart! A Quarter Horse or Thoroughbred Pinto can also be called a "Paint."

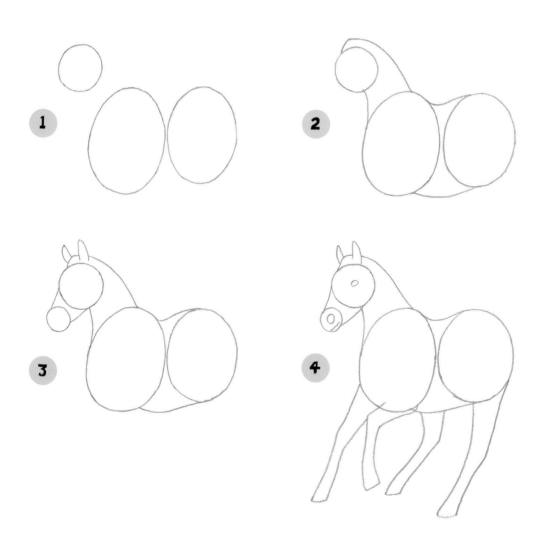

fun fact Both Pintos and Paints have the same patterns of coloring, so how can you tell the difference between these breeds? Every Paint is a Pinto, but not every Pinto is a Paint. The Pinto registry is less exclusive than the Paint registry.

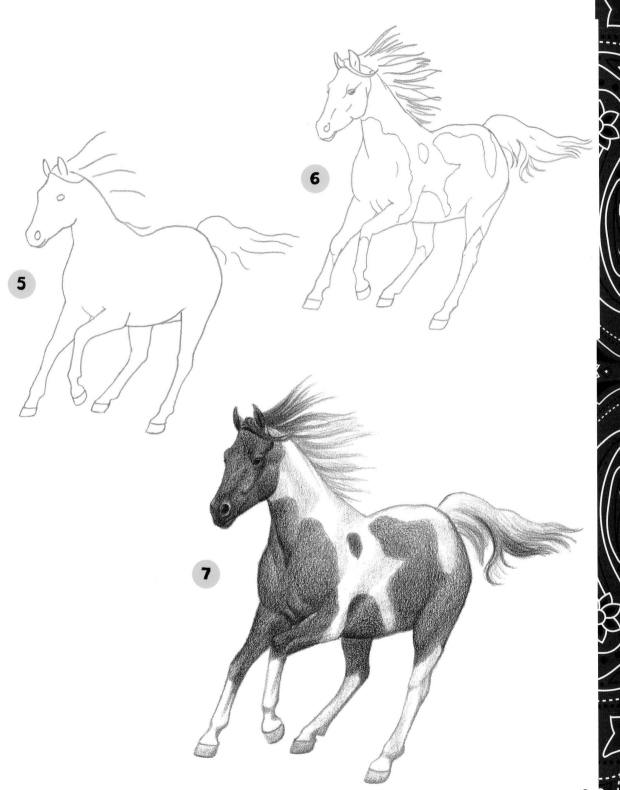

Welsh Mountain Pony

This little foal is as cute as can be! First draw its sturdy, round body. Then add super long legs!

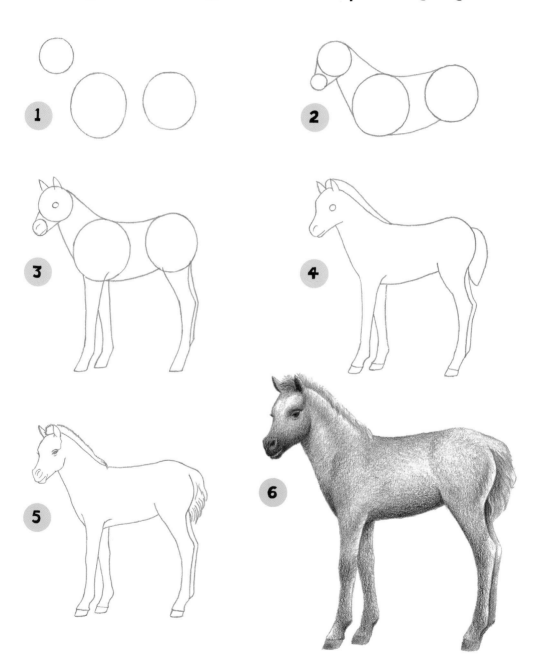

Norwegian Fjord Pony

This primitive-looking pony has zebra stripes on its legs and a dark stripe on its back that goes right through its mane!

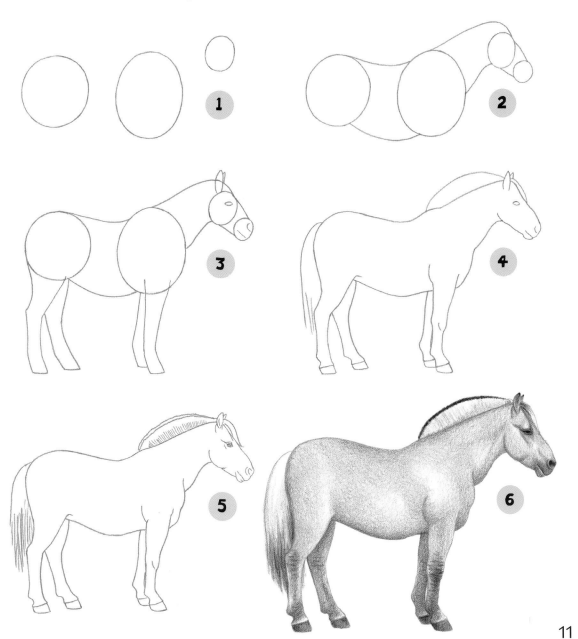

Clydesdale

The clydesdale is a big and powerful draft horse, with long leg hairs—called "feathers"—that almost cover its hooves!

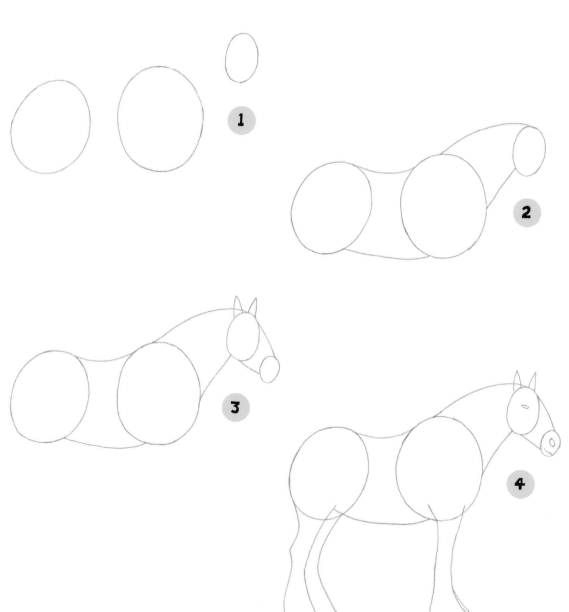

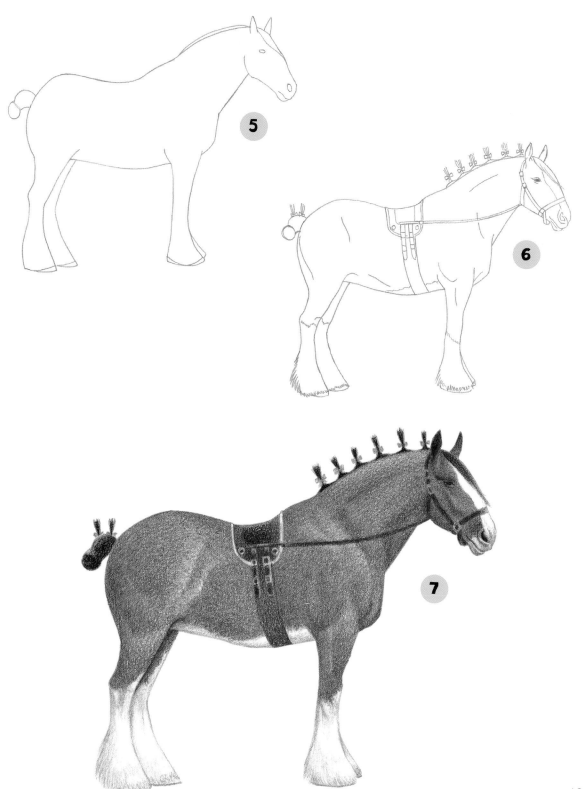

5

6

7

Arabian

Its delicate, dished profile, large eyes and nostrils, and small, pointed ears give the Arabian a noble and gentle appearance.

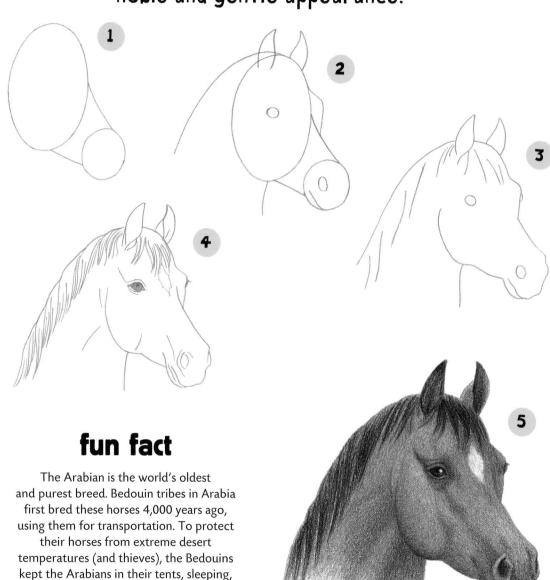

fun fact

The Arabian is the world's oldest and purest breed. Bedouin tribes in Arabia first bred these horses 4,000 years ago, using them for transportation. To protect their horses from extreme desert temperatures (and thieves), the Bedouins kept the Arabians in their tents, sleeping, resting, and eating with their steeds by their side.

Noriker

An ancient Austrian draft breed (heavy workhorse), the Noriker is strong and stocky, with a long silky mane, tail, and forelock.

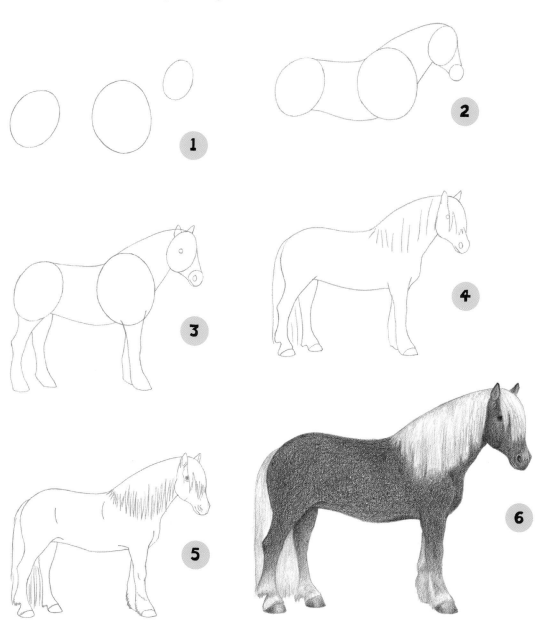

American Saddlebred

This high-spirited horse shows off its proud style with a high-flying tail and a prancing step!

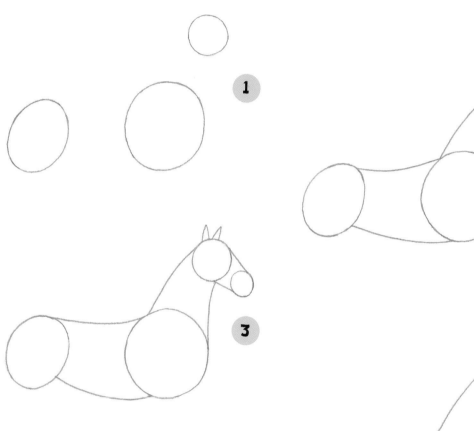

fun fact

The Saddlebred not only walks, trots, and canters—it can also perform two additional smooth, easy-riding gaits: *slow gait* and *rack*. Some horses can carry out the five gaits naturally at birth, but others must be trained to perform the two special gaits.

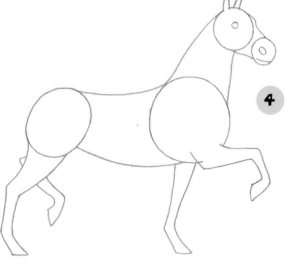

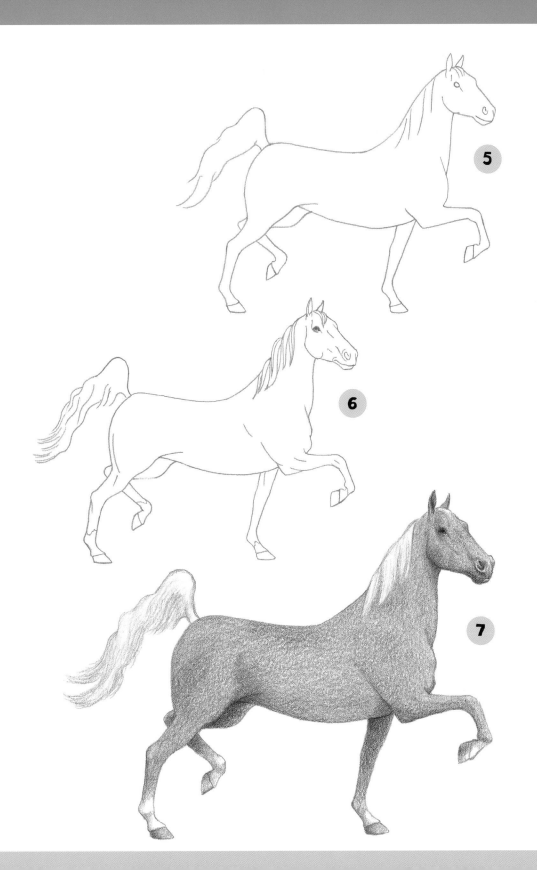

5

6

7

Morgan

Small but super strong and hardy, the Morgan has a draft horse's muscular hindquarters but thinner legs and an elegant face.

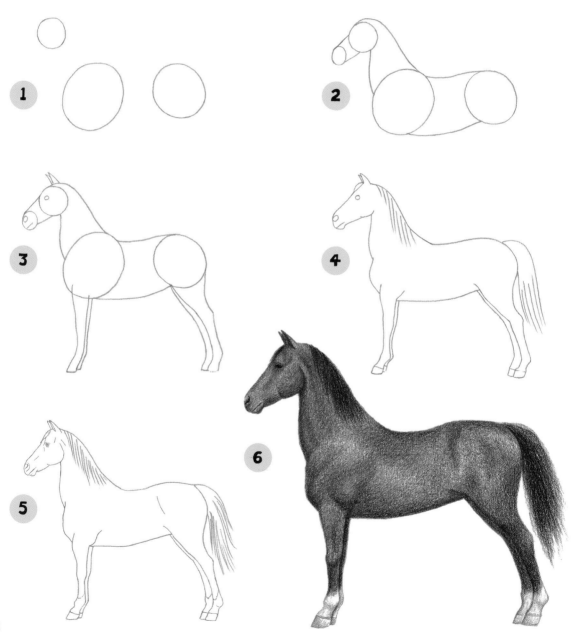

Thoroughbred

The fastest breed in the world, the athletic and courageous Thoroughbred can run and jump for miles and miles!

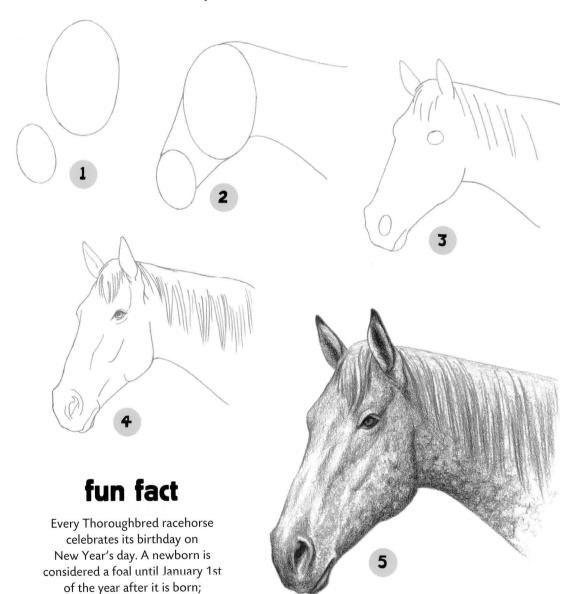

fun fact

Every Thoroughbred racehorse celebrates its birthday on New Year's day. A newborn is considered a foal until January 1st of the year after it is born; then it's called a "yearling."

Horses in Action

whether working or playing, horses and people have been partners for thousands of years! Try your hand at drawing these active horses as they run, jump, and show off their skills!

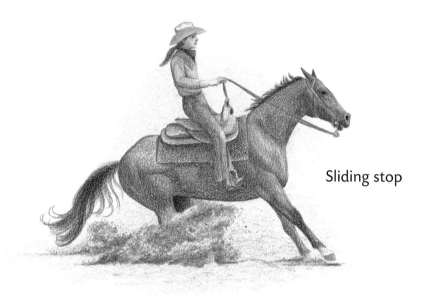

Sliding stop

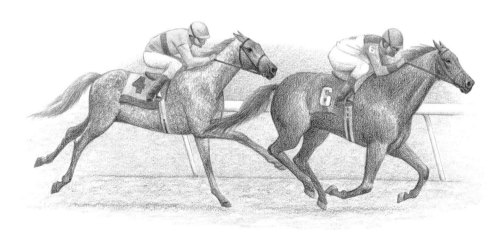

Racing

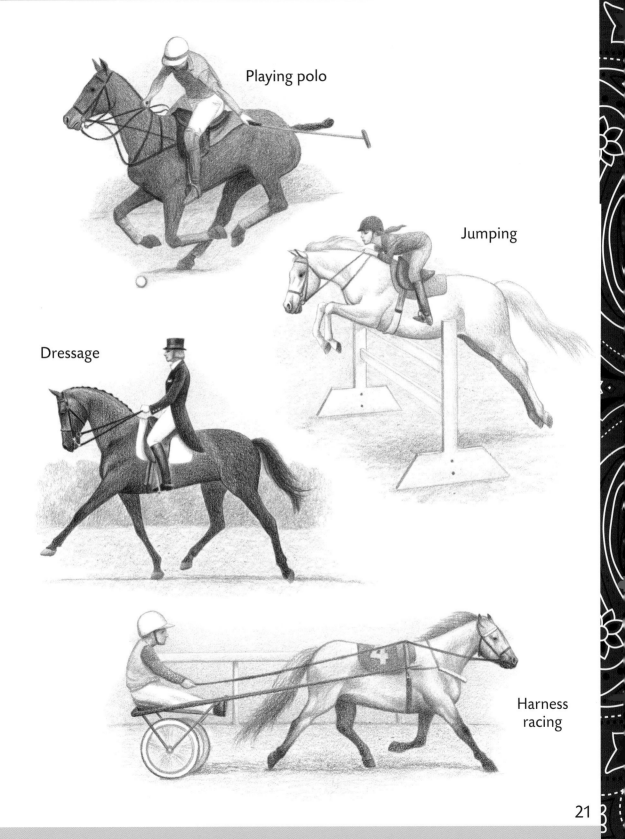

Playing polo

Jumping

Dressage

Harness racing

Friesian

Rapunzel would envy the long, flowing locks of this solid black Friesian—a heavy draft horse from the Netherlands.

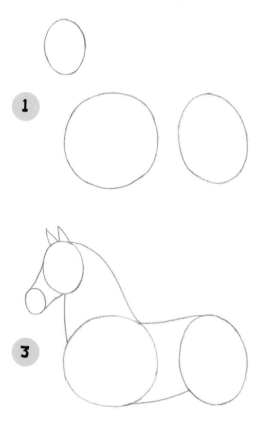

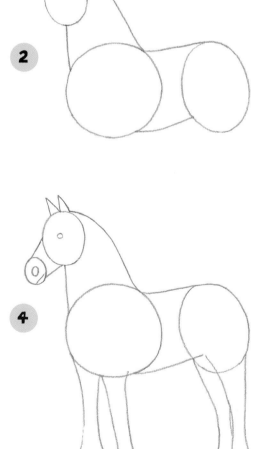

fun fact

With its wild, long hair, the Friesian looks like a horse "rock star." And, wouldn't you know, this horse has a tattoo too! When a foal passes inspection, its registration number is tattooed underneath its tongue.

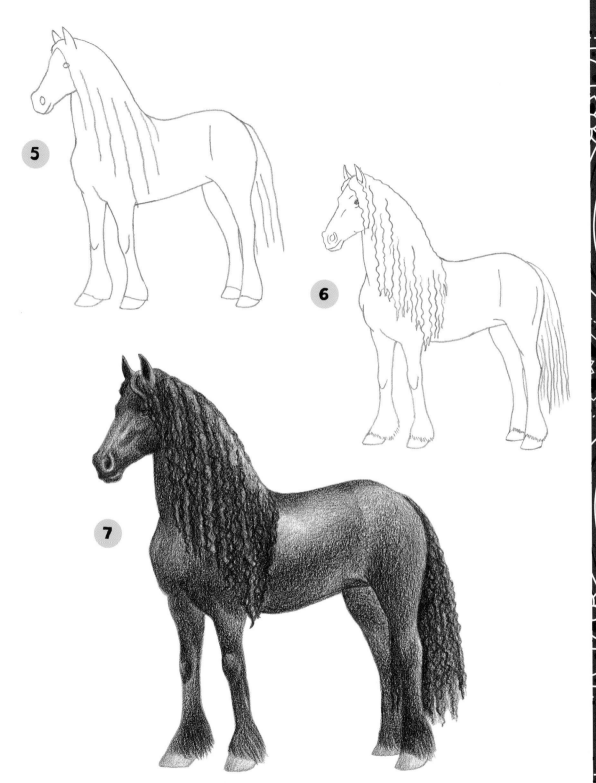

5

6

7

Shetland Pony

A favorite breed of pony-loving kids, the adorable Shetland is tiny but tough, with a round belly and short, stocky legs.

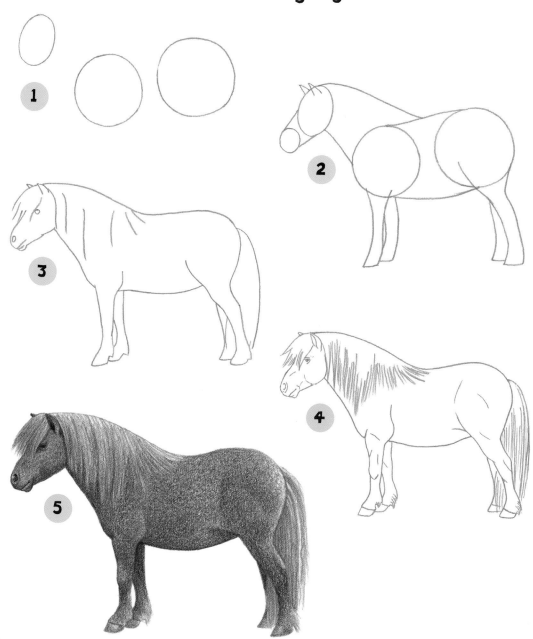

Kathiawari

This narrowly built horse from India has distinctive ears that curve inward until their tips actually touch!

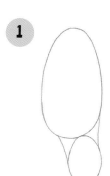
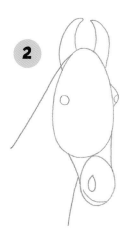
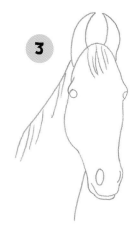
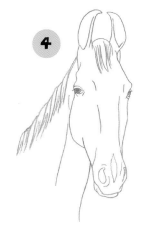

1

2

3

4

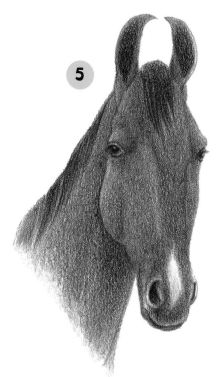

5

fun fact

This horse is small, but it's also tough, which is why the Kathiawari is a favorite of tent-pegging athletes. Originally a way to practice wild boar hunting, *tent pegging* is now a popular sport in India. To play the game, an athlete rides to the center of an arena and, while on horseback, uses the tip of a lance to pick up a small wooden block—or peg. Picking up the peg earns the rider half a point; picking up the peg and carrying it to the opposite corner of the arena earns a full point.

American Quarter Horse

with its muscular hindquarters and powerful shoulders, this Western horse can sprint like an Olympian and stop on a dime!

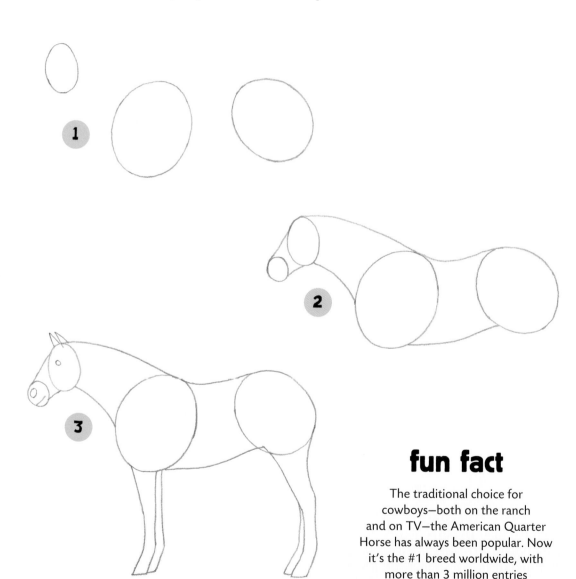

fun fact

The traditional choice for cowboys—both on the ranch and on TV—the American Quarter Horse has always been popular. Now it's the #1 breed worldwide, with more than 3 million entries in the American Quarter Horse Association registry!

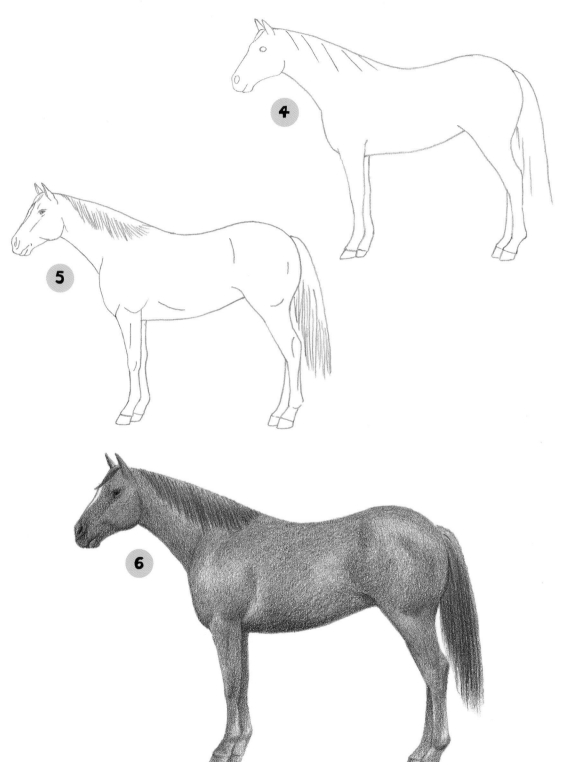

Appaloosa

The easy-going Appaloosa is awash in spots!
Along with its frosted coat pattern, it has
a multi-colored tail.

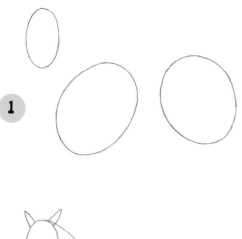

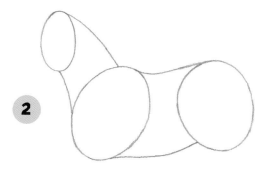

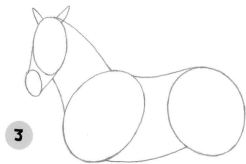

fun fact

The first horses in the United
States arrived in 1493. By 1780,
most Native American tribes
had horses, including the Nez Percé
of the West. Expert horsemen,
the Nez Percé selectively bred
spotted horses, which later
became the Appaloosa breed.

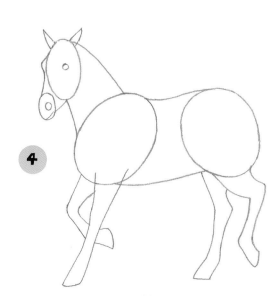

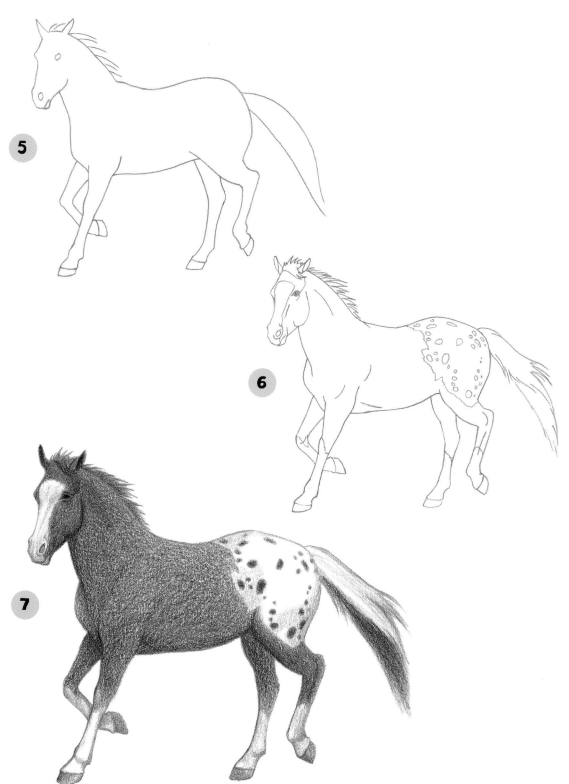

5

6

7

Highland Pony

This sure-footed Scottish pony has the build of a draft horse, with soft, silky feathers on its lower legs.

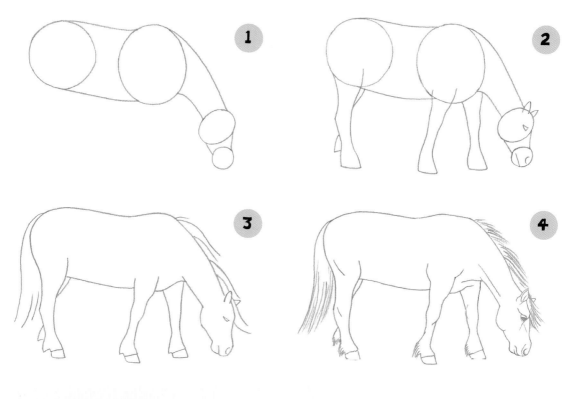

fun fact

Highland foals often have "primitive" markings on their coats, including stripes on the back, shoulders, and legs; or dark spots on the mane, tail, and legs. Some of the markings fade over time, but others continue to show throughout the ponies' entire lives.

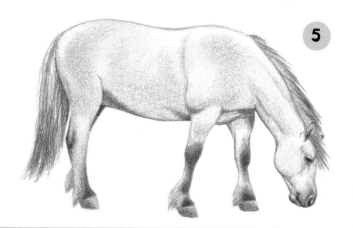

Paso Fino

Also called a "stepping" horse for its natural, lively gait, the Paso has long hind legs and pasterns and very flexible joints.

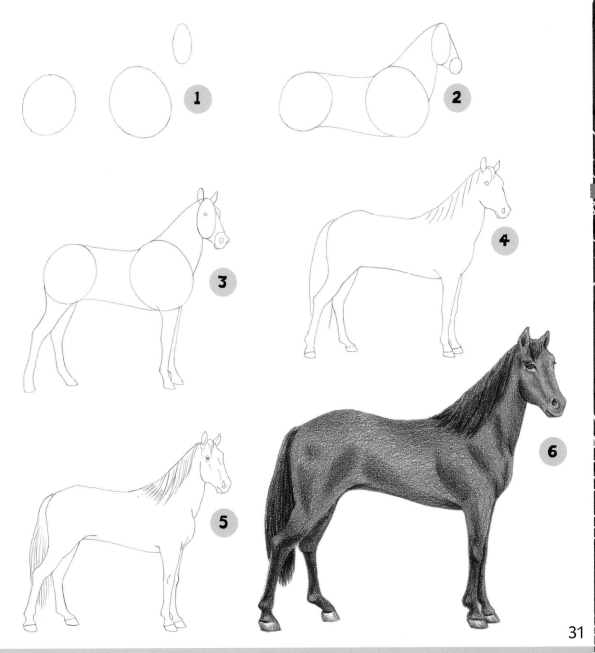

Percheron

The unfeathered Percheron is a popular heavy breed. Despite its size, it has the elegance of its Arabian ancestors.

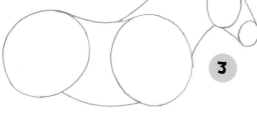

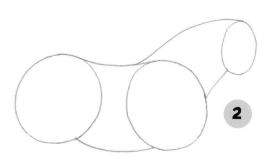

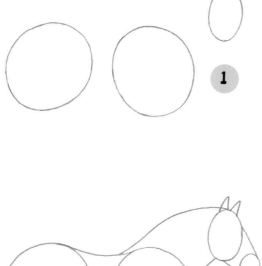

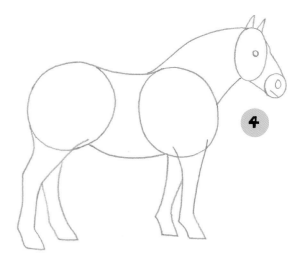

fun fact

Three of the foals recorded in the first American Percheron stud book in 1876 were fathered by a horse named Diligence. Diligence, a native of La Perche, France, arrived in the United States in 1839; once in the states, he reportedly sired more than 400 foals!

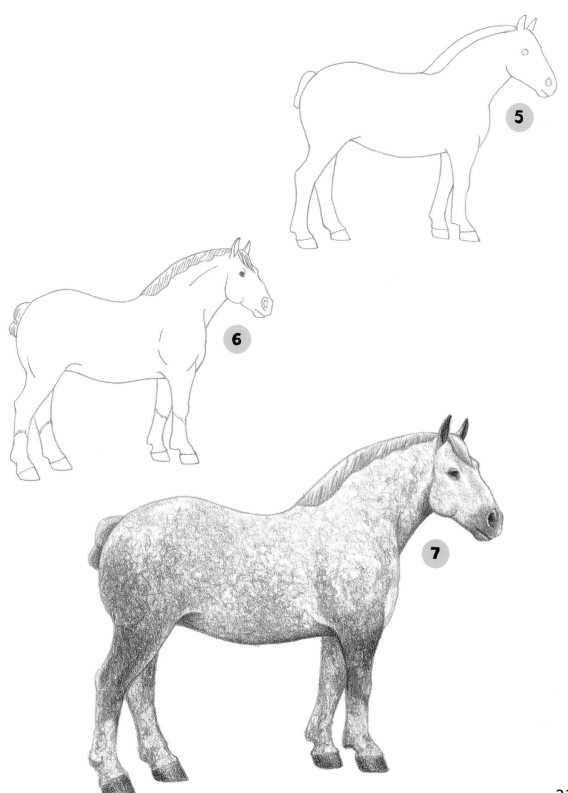

Pony of the Americas

This polka-dotted pony has a two-toned mane and a long, arched neck. Draw its spotted coat with circles and ovals.

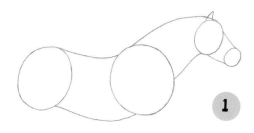

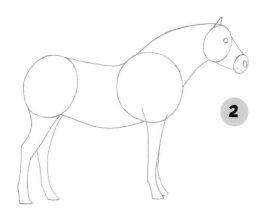

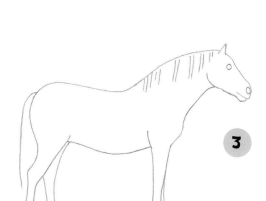

fun fact

In 1954, an Iowan breeder named Les Boomhower discovered the unique coat of a foal born with an Arab/ Appaloosa mother and a Shetland father. This foal was the first Pony of the Americas, a breed developed for children to show and ride.

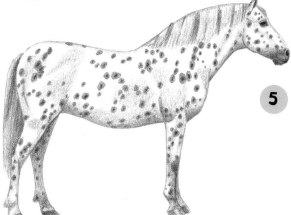

Tennessee Walking Horse

with its ultra-smooth walk, this gaited horse is a proud show-ring competitor with a sweet, gentle personality.

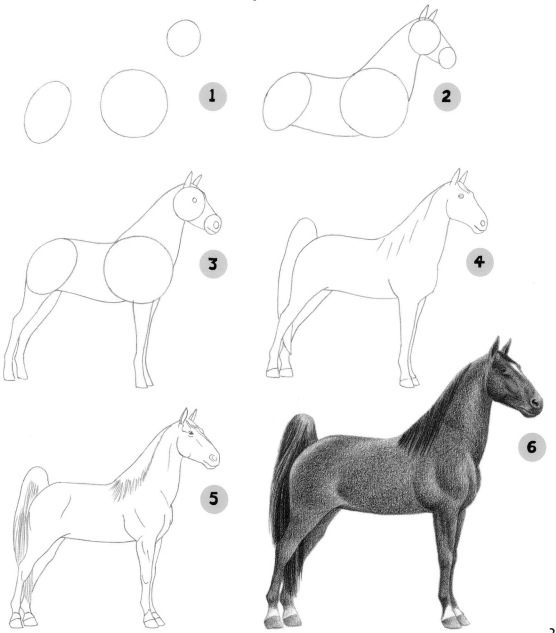

Dutch Warmblood

Although it's not as tall as its mother, the legs on this athletic foal are already nearly as long and almost as strong as hers!

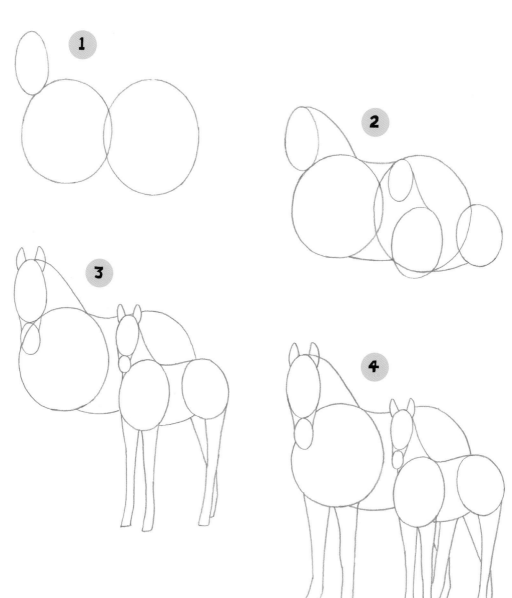

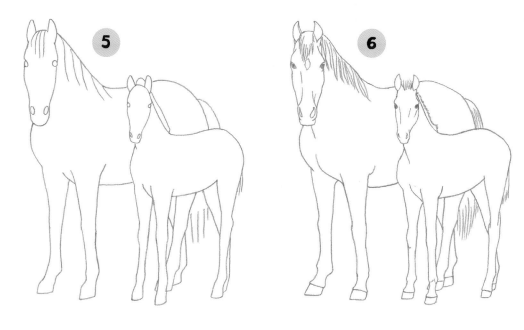

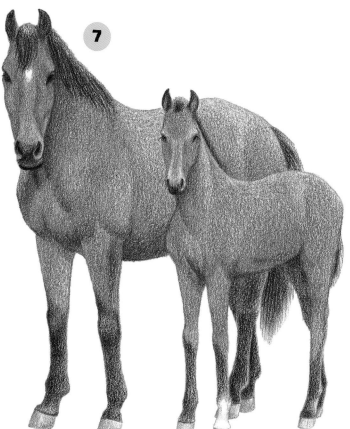

fun fact

Most horses are registered according to their ancestry. For example, if a horse has a registered mother (dam) and father (sire), it's considered to be that breed. But the Dutch Warmblood has an "open" studbook. So regardless of its ancestry, a Dutch Warmblood foal is never automatically accepted for registration.
Every foal must first be inspected for breed-worthiness!

Rocky Mountain Pony

Its dappled chocolate coloring and creamy mane and tail make this pretty pony a one-of-a-kind sensation!

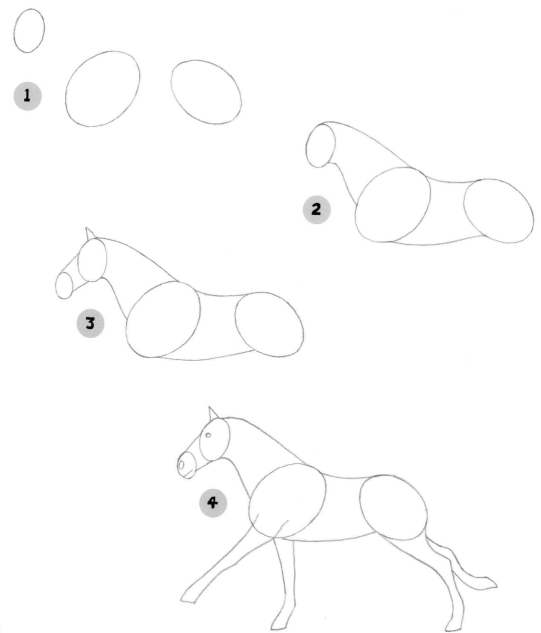

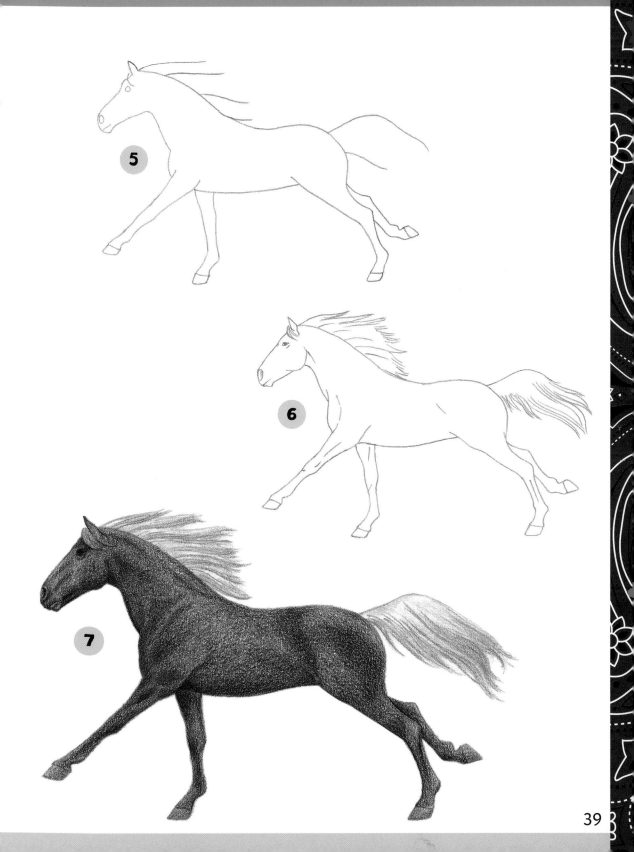

Andalusian

This noble breed is a fabulous gymnast, just like its descendants: the famous "dancing" white Lippizaners of Vienna.

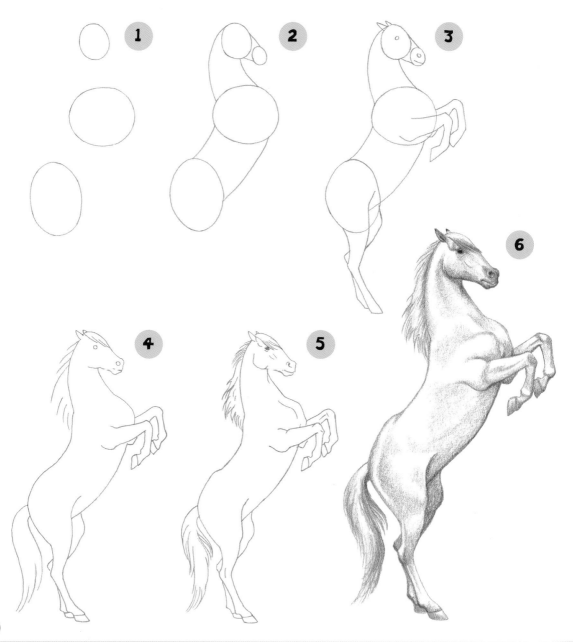